On Creating Things Aesthetic

On Creating Things Aesthetic by Leonard Koren

© copyright 2023 by Leonard Koren

Published by Imperfect Publishing
POB 608, Point Reyes Station, CA 94956 USA
imperfectpublishing.com

Many thanks to Emilia Burchiellaro, Peter Goodman,
Marco Koren, Dave O'Hare, and Kitty Whitman for
their help in creating this book.

ISBN 9781734914313

Printed in Italy

5 4 3 2 1

CONTENTS

Definitions 8

A (very) short story 11

Context 23

Basic operation #1: Assimilating 24
#2 Copying and repeating 27
#3 Combining 28
#4 Deconstructing 31
#5 Subtracting 32

Practice 37
Instinct and intuition 41
Rationality 42
Questioning 46
Provocation 49

Unsticking brain glue 53
Surrendering to chance 57

What if? 63

TEXT NOTES 70
PICTURE NOTES 75

To create = to bring new things into existence. Also to bring things that already exist, but have been ignored or forgotten, back into awareness.

Things = tangible and intangible objects (physical artifacts, environments, concepts, atmospheres, etc.)

Things aesthetic (aesthetic things) = things with pronounced sensorial, emotive and/or poetically resonant qualities.

Creators = people who create aesthetic things.

Note: Unlike gods who can create something-ness out of nothingness, human creators can only combine, reconfigure, strip down, extend, or otherwise alter and/or respond to things that already exist. Human creators, however, often do this in remarkably clever ways.

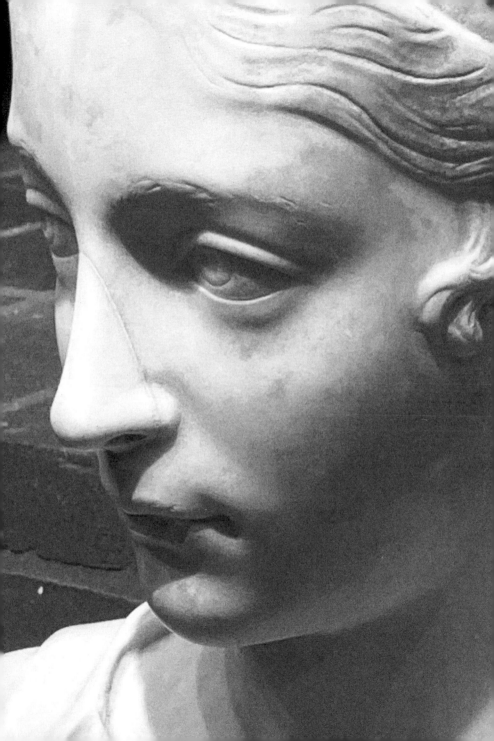

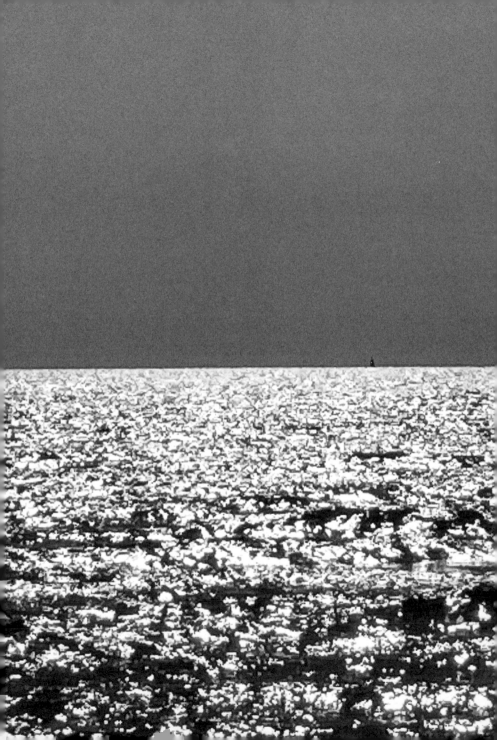

A (very) short story: The methods, strategies, and procedures we use when creating things—i.e., the methodologies—largely determine the character of the things we create. This cause-and-effect relationship has long intrigued me. So, I wasn't surprised when "methodology" came to me as the answer.

The question was: "What should my next book be about?" This is what I asked myself at the beginning of a brainstorming/stream-of-consciousness session. With a pad of paper on my lap and a pencil in hand, I gave my imagination free rein while trying to keep rational thoughts at bay.

All of this occurred as I sat on a beach on the Mediterranean, staring out at the horizon.

Exactly one year earlier, my wife, son, and I had relocated from Marin County in Northern California to a small Italian hilltop town about an hour north of Rome. Each of us had our own reasons for the move. Mine was exasperation, but also boredom, with the "tech-this, tech-that" mindset that permeated the San Francisco Bay Area.

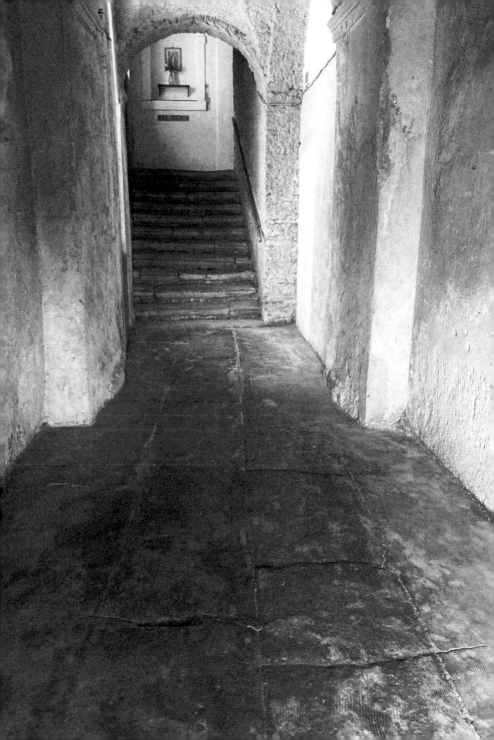

Our new abode was an apartment on the top floor of a building constructed in 1480. Structurally the building seemed sound, but the visible consequences of benign neglect were everywhere. (Is "benign neglect" a methodology?)

The floor tiles were cracked in a hundred different ways. The walls were crooked and patched over in a mishmash of surface treatments. . . .

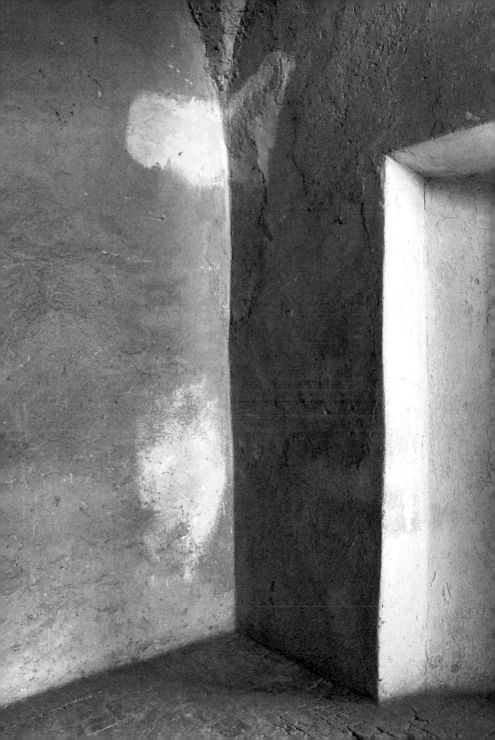

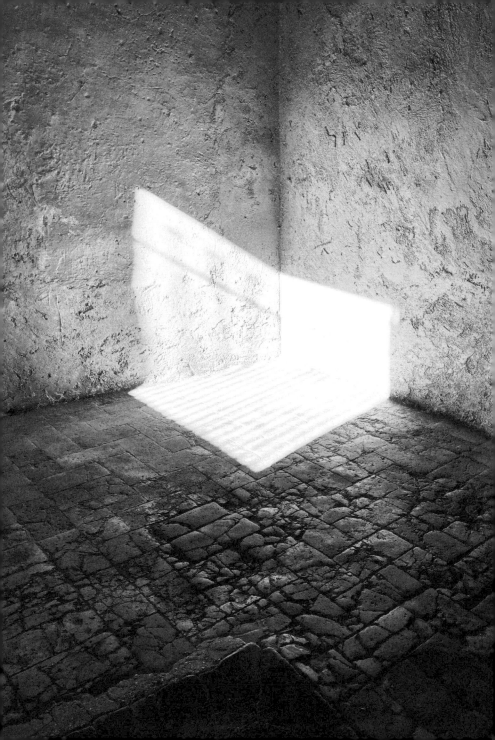

On the other hand, the building was the locus of some extraordinary, naturally occurring phenomena. In the summer, for instance, the sun fell on the intersection of two walls creating a luminous volume that—with a little imagination—looked like a cube of pure white light hovering in space. (It was the same effect that I had seen James Turrell trying to create early on in his fine art career, but with artificial xenon light.)

The fly in the ointment of our small-town existence was the drive to and from our son's school. The scenery along the way was lovely, but the twice-daily back-and-forth trip could take up to five hours. My wife and I shared the task, yet it quickly became mind-numbing. Sensibly, my wife suggested moving to Rome where our son's school was located. I was opposed to the idea. I didn't like Rome. I thought it was an unmodern city unhealthily fixated on its past. Eventually, though, I came around. After a bit of searching, we rented a pleasant apartment in a quiet neighborhood not far from the Tiber River.

Almost instantly I felt at home. Throughout its twenty-seven-hundred-year history, Rome has experienced virtually everything. Romans, consequently, often expressed a resigned cynicism about the human condition. For instance, in early January I asked Alessia, who works at our favorite bakery, how the new year was treating her. She smiled dryly, then responded, "No complaints—yet. But there are still twelve months."

Context. What does the preceding narrative have to do with creating things aesthetic? In words and pictures I have just established the basic form, style, tone, and attitude of what and how I want to communicate. That is, I set up a context for what is to follow.

Without an appropriate context, the things we create can be easily ignored or misunderstood.

Basic operation #1: Assimilating. If we reverse-engineer the act of creation, what we find is an agile, inspired imagination skillfully driving a few straightforward mental operations. Assimilation—absorbing the world of yesterday and today—is probably the first of these operations in which we engage. A good illustration of this is how the Beatles came to write many of their songs.

Prior to the group's formation, each not-yet Beatle had fully immersed himself in the music, past and present, of rock-and-roll and related genres. When the four lads first got together, they played cover versions of these same songs hundreds, but more likely thousands of times. When the Fab Four finally got around to penning their own tunes, they continued to play the canonical songs of the past and present even during the lulls and in-between moments of their composing sessions.[1] With their vast reservoir of absorbed musical knowledge always at the forefront of their consciousness, the group was then exceptionally well positioned to reconfigure the old into something new. And so they did.

#2 Copying and repeating. After assimilating the world that we are born into, our first response is usually to copy and repeat the things that attract us. It could be a feeling, a sensation, a quality of sound or image. It could be anything. Every act of reproduction or representation is an attempt to copy or repeat some aspect/s of things that already exist.

Copying and repetition also come into play when we set about learning new skills. Practice makes better. But once we ingrain what we want or need to know in our mental muscle memories, most of us are happy to leave the copying and repetition behind.[2] Unfortunately we can't, at least not completely. A ghostly repetitiveness persists. It manifests as an echoing of specific themes, inquiries, or expressive quirks that keep reappearing in whatever we create. It may be something that we don't perceive ourselves. But others do.

#3 Combining. Combining by juxtaposition entails placing things next to, on top of, or interwoven, embedded, collaged, or squished together with any other thing or things. The manner and variety of juxtaposition is infinite: Objects with objects. Objects with ideas. Tastes with textures. Facts with fiction. . . .

The identities of the individual things juxtaposed remain distinct. For example, a dance is composed of one recognizable body movement and/or gesture sequenced next to another, then another. . . . A typical living room is one physical object next to, on top of, or beside another, and another. . . . The precise manner in which things are combined—the order, the emphasis, the nuances of the combination, etc.—is, of course, just as consequential as the constituent things themselves.

In another type of combining, synthesis, the identities of the individual things combined disappear or dissolve within the new thing created. This is what happens, for example, when red paint combines with blue paint to create purple paint.

#4 Deconstructing. In every corner of the aesthetic universe where change for the sake of change is an imperative (which is just about everywhere), deconstruction is a go-to methodology. Deconstruction involves taking an inventory of all the elements or features of the thing to be created and then interrogating each in turn: Could, or should, this element or feature be changed? If so, how?

Binary-mode deconstruction, the most conspicuous variant practiced, simply entails changing things in a way opposite to what would typically be expected. Everything is fair game for deconstructive transformation (except, perhaps, the underlying archetype): If the standard version of a thing is small, make it big (or vice versa). If it's thick, make it thin. If it's slick and shiny, funk it up, dull it down. Smooth and nicely pressed? Work in some wrinkles. If it's a fully integrated whole, break it up into its component parts. If it's hard, make it soft. Straight? Render it curvy. Opaque? Try transparent. Plain? Decorate it.[3]

#5 Subtracting. Subtraction is a catchall term for procedures that involve the creation of something "more" by making "less." Here are a few examples:

DE-MUDDLING: Get rid of what is unnecessary. The obvious first question: What is unnecessary? Remove anything and everything that could possibly lead to confusion or misunderstanding. Jettison the ambiguous, the vague, the ill-defined, or whatever else hinders or obscures a clear perception of the coherent aesthetic whole that we are trying to create.

REDUCTION: Reduce in size, weight, number, and extent. Shrink down. Make smaller. Limit the number of elements and operations. Impose constraints, then stick to them. Resist the urge to do more.

REFINEMENT: Literally (or figuratively) prune, sand, grind away, and polish. Turn a thing—tangible or intangible—over and over again until a dazzling simplicity is revealed.

ABSTRACTION: Ditch the details. Isolate the salient elements and consolidate them in a concentrated form. One of the major thrusts of modern art of the last hundred years has been just this exploration. . . . What is the purest essence of a painting? (The numerous late-twentieth-century monotone canvases in all-black, all-white, all-blue, all-red, all-gray, all-green.) What is the essence of a modern city plan circa 1940? (Piet Mondrian's "Broadway Boogie Woogie").

DISINTEGRATION: Monitor and curate deterioration. Let surfaces gracefully fall away to reveal interesting underlying structures. (Like the skeletal remains of an earlier civilization at the site of the Roman Forum.)

Practice. The use of the word "practice" as in "her creative practice involves . . ." began showing up with increased frequency during the 1970s in academic papers relating to conceptual art.[4] The conceptual artists of that period produced many interesting ideas but few, if any, physical artifacts. So what were the critics and the art historians of that era to write about?

Fortunately most conceptual artists could articulate, with remarkable clarity and specificity, the substance and subtleties of their thinking. This articulation was perceived to be a part of the art itself. "Practice" then became the term used to denote the totality of thought, intention, and action constituting a conceptual artist's working life—at least according to those writing about it.

Subsequently, as contemporary art in general began to evolve in a more idea-driven (i.e., conceptual) direction, this use of "practice" expanded even further. Today the term is used by most creators in the aesthetic domains to describe the essential contours of their working lives and creative production.

Many of our creative practices are similar to the methodologies of scientists. In both the aesthetic and scientific realms hypotheses are developed. These involve conjecture and speculation about the way things may be, can be, or should be. These hypotheses are then tested. In the aesthetic domains we usually do this by making or doing things. If our hypotheses perform well, we usually continue in that direction, at least until we feel the need to develop a new hypothesis. If something completely unexpected arises during any of these stages—say, a "happy accident"—then we either seize upon this new possibility immediately or save it for future exploration.

MEDIUM GRAY

MARS BLACK

IVORY BLACK

PAYNES GRAY

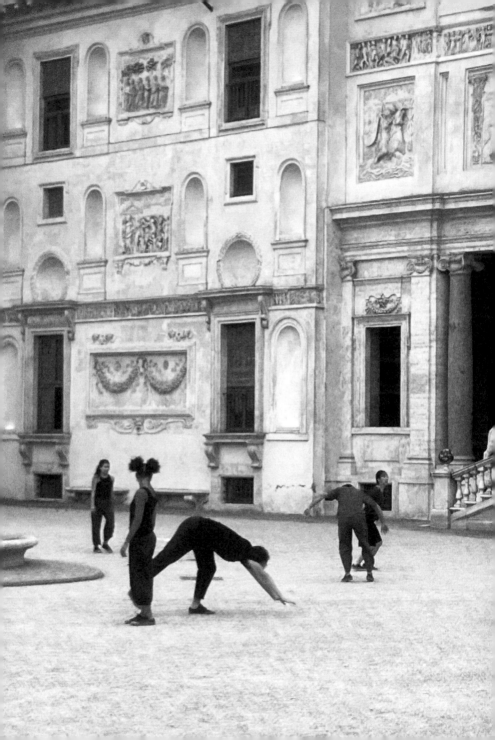

Instinct and intuition. What drives the basic mental operations that are involved with creating? In other words, what is the source of our "agile, inspired imaginations"? Primarily our instincts and intuitions. Instinct is the more primal of the two. It comprises thought and behavioral impulses that we share with other members of our herd (or sub-herd) and that are imprinted in us either genetically or through conditioning. Intuition, on the other hand, is knowledge that we have synthesized from all of our observations and experiences of how the world works, underpinned by our instincts.

Both instinct and intuition are ways of knowing that come to us as inklings, feelings, hunches, flights of fancy—sometimes even as "voices." In other words, from somewhere other than the conscious sense of the "me-self."[5]

In practical terms instinct and intuition work by nudging us in one way or another to place a dab of red paint here . . . add more sugar or cinnamon there . . . leave out the punctuation . . . or turn a ritual of life into a dance.

Rationality. Instinct and intuition can take us a very long way, but usually not all the way. That's why our rational mind—our ability to think logically, analytically, and in a "common-sense" manner—often kicks in. Yet it is difficult to discern when one mental process begins and ends, and another starts. Our various cognitive modes constantly overlap one another.

For instance, when we look at *The Crucifixion of Saint Peter*, a painting by Michelangelo Merisi da Caravaggio (1571–1610) on display at a church in Rome's Piazza del Popolo, there is clear evidence of Caravaggio's complex mind at work. But which operations of that mind? Is it instinct, intuition, or some flavor of rationality that has dictated the intense drama created by the bizarre composition, the void-like background, and the cleverly obscured faces of the workmen carrying out their grim task? Are the rhetorical schemes that Caravaggio visually employs—metaphor, allegory, irony, and paradox—put there instinctively, intuitively, or with rational intent?

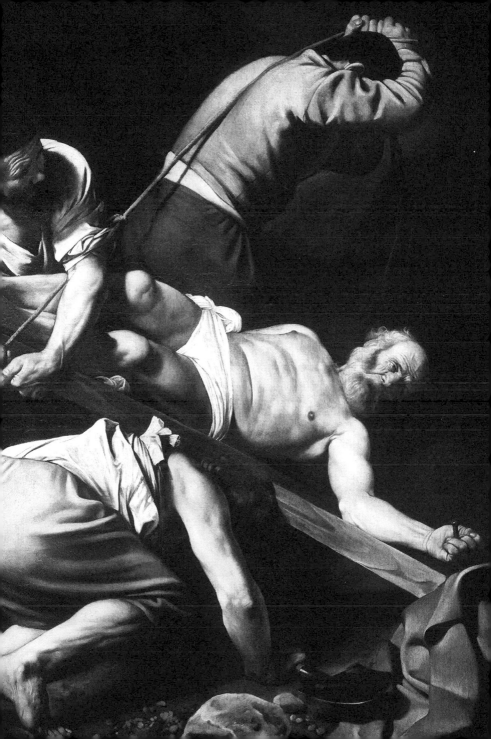

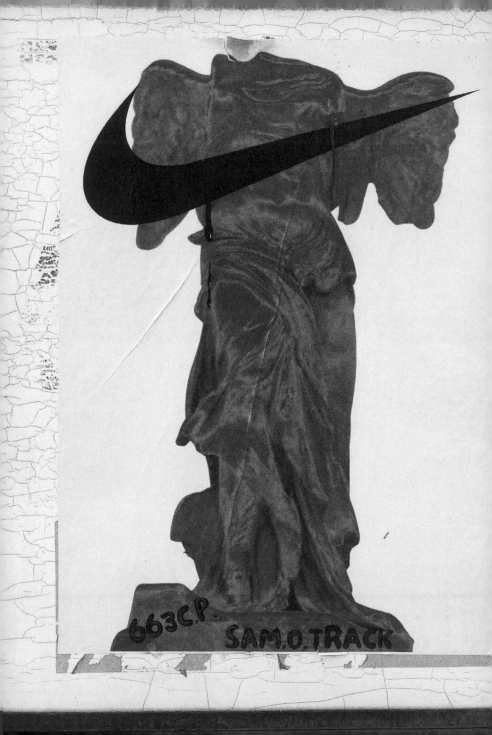

The same questions about the interplay of instinct, intuition, and rationality could be asked of the creator of a poster recently pasted illegally on outdoor surfaces around Rome. Through what mental process/es did she, he, or they come upon the idea of combining a photograph of an Ancient Greek sculpture of the goddess Nike with a sports-shoe-brand logo?

Questioning. Asking questions repeatedly—incessantly—is an ongoing feature of the creative process. "Are my premises sound?" "How can I go deeper?" "What's missing?"

Often our questions are asked directly. But sometimes they're posed as statements: "This is terrible"—which is usually followed by "What can I do to fix it?" Sometimes our questions are disguised as feelings: "This doesn't feel right," which translates as "Exactly what doesn't feel right?" And "What is the reason for that?"

How is it that we can both ask and answer the same question? We just can. And that's fortunate because our questions frame and direct the thinking that determines the answers that eventually come to us. The more distinctive and interesting our questions, the more distinctive and interesting the responses that arrive. And they do arrive, if we keep an open mind, either as direct statements, epiphanies, intuitions, or dribbled out in bits and pieces, as in dreams.

Provocation. When there's an impulse to shake things up—to break through the stifling conventionally of it all—we can turn to provocation. Provocations of a benign and modest sort include mystification, demystification, surprise, making the strange seem normal, or the normal strange. . . . If that isn't strong enough we can ramp up to mild transgression by flaunting sloppy craftsmanship, "dumb" composition, or outrageous "bad taste." But if that doesn't scratch the itch, we can move into offensiveness and blatantly copy the work of others and call it "appropriation." Or erase, torch, or otherwise deface the work of an established masterpiece and declare it an act of "creative transformation."

And who knows? No matter how silly, stupid, or insipid the things we create may seem at first, they might just become the next *great new thing*. . . . That's because the transmission of aesthetic fashions is similar to that of viral pathogens. And while there are vaccines that can protect us against actual viruses, none exist to protect us against those of the aesthetic sort.

In 1961, when artist Piero Manzoni packaged his feces in metal canisters labeled "Artist's Shit"—and pegged the price of his fecal-matter-filled cans to that of gold—it was, in retrospect, a brilliant conceptual artwork. Through conventional eyes of that time, though, it was a not-so-veiled "fuck you" aimed at the art establishment, which also included Manzoni's "self-important" fellow artists. Luckily for Manzoni there was just the right amount of black humor and perverse truth in his provocative incitement to save him from the art world's wrath, or worse, its indifference.

Today Manzoni's canonical excrement, applauded for its gentle naughtiness, is proudly collected by major art institutions around the world.

This raises an interesting question about the methodology of provocation: If the threshold of unacceptability keeps rising, what, if any, is the upper limit?

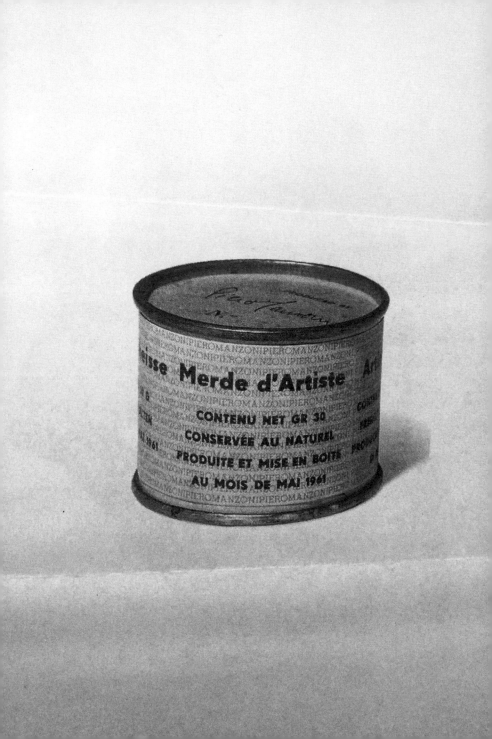

Unsticking brain glue. If the word "creativity" has any meaning, surely venturing into aesthetic terra incognita is a facet of it. But exploring the unknown has its risks, and risk implies the possibility of failure—the thought of which can induce a kind of performance anxiety. Solution? Move forward, one small step at a time—but not necessarily in a straight line.

The recursive methodology sometimes employed by Justin Bradshaw is a good example. Instead of purchasing the paints he needs at an art supply store, Justin occasionally takes a roundabout route. While wandering amongst the hills, fields, and valleys of the countryside just north of Rome, where he lives and works, Justin collects rocks, soils, and other elemental materials whose colors appeal to him. He then grinds these down into powders and mixes them with oil. The unctuous compounds are then encased in metal tubes. If another idea hasn't already popped into Justin's brain, he uses these lovingly made pigments to paint pictures of . . . tubes of paint.[6]

My approach to unsticking brain glue involves taking a brisk walk, partially through Rome's tourist-packed historic center, partially along the peaceful Tiber River. This radical change of contexts resets my point of view. The increased blood flow to my brain boosts my mental alacrity. Unfortunately, this routine doesn't always do the trick. When the conceptual wall seems too high or I've struggled far too long, I simply give up, lie down, and take a nap. If upon awakening there's still no progress, then I (figuratively) throw the project away and let it marinate, and hopefully blossom, in that mysterious medium we call time.

If I'm lucky, and I usually am, the volitional spirit of the thing that I'm trying to create will eventually inform me that it's time to reenter the fray. I realize, of course, that it's actually my own sense of agency letting me know that a critical mass of ideational momentum has finally arrived. But I prefer to think of it as magic.

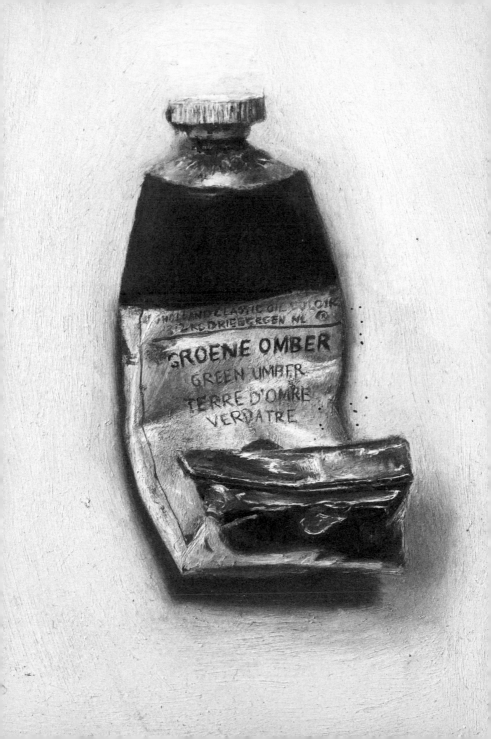

Surrendering to chance. Sometimes we don't want to make decisions. It's not that we can't or are unable to but rather desire that our next move come from a place beyond our usual controlling mind with its predictable prejudices and tastes. Perhaps arbitrariness, the wisdom of the universe as reflected in the random workings of chance, is the answer. Flipping a coin, rolling dice, or blindly selecting options scrawled on slips of paper all work well here—as long as we make sure to include a good number of options that reflect unusual impulses. Of course, we also have to commit to follow wherever chance leads us, even if that seems unappealing at the moment before we make our move. Otherwise we're back to the same old same old.

Another way of letting chance take us where it will is by seeking the advice of oracular systems such as the tarot or the *I Ching*. The literal insights of these systems are often valuable, but so is parsing the evocative, ambiguous language in which their nuggets of wisdom are encapsulated. A content analysis of the *I Ching* reveals, however, that half of the advice it gives is to be "more thoughtful." The other half is to either "wait before taking any decisive action" or to simply "refrain from taking any action whatsoever."[7]

More dynamic suggestions can be found in contemporary oracular systems like Oblique Strategies (a deck of advice-and-question cards created by Brian Eno and Peter Schmidt), which advises the following: "Don't be frightened of clichés" and "Balance the consistency principle with the inconsistency principle." And possibly its most helpful prompt of all: "What wouldn't you do?"

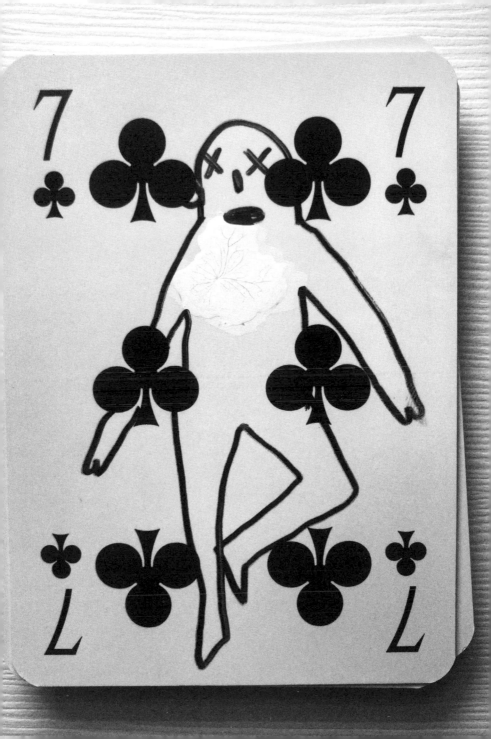

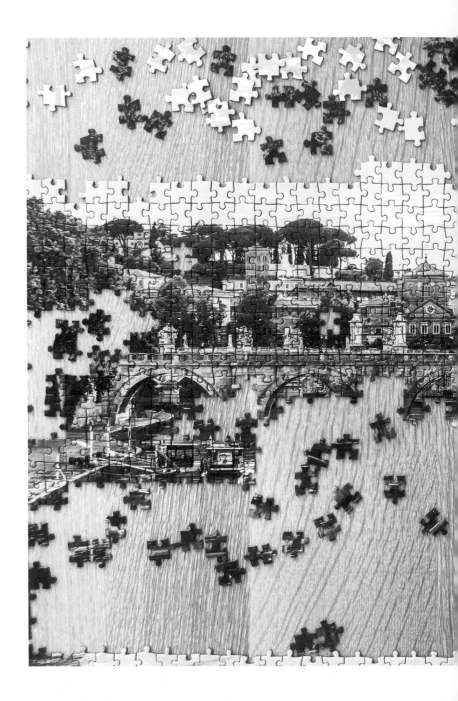

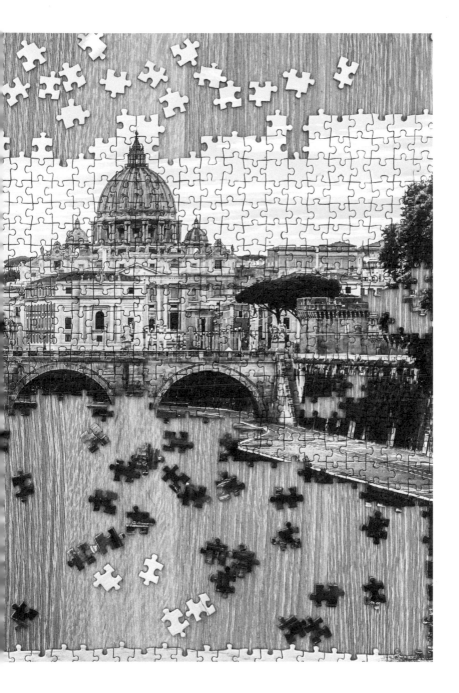

What if? In so-called practical domains such as commerce, applied science, and plumbing, dramatic progress seems to occur over relatively short timespans. Look at our ability to perform mathematical computations. We have leapt from the abacus to the supercomputer in less than two centuries. In transportation technology we have gone from the horse and buggy to rocket-powered space travel in less than half that time.

Progress in the aesthetic domains, however, is of an entirely different order. Not so many decades ago Pablo Picasso painted images of bulls that looked very much like the bison painted on the walls of the Altamira caves in Spain over ten thousand years ago. Picasso's bulls were lauded, but how innovative were they really? Another example: The Pantheon, an almost two-thousand-year-old building standing in the middle of present-day Rome. Do today's architects really create public spaces with qualities of light and euphoria-inducing grandeur surpassing those of the Pantheon? And what about Homer's *The Iliad* and *The Odyssey*, both created

three millennia ago?[8] Why are their illuminating insights into the human psyche still constantly replayed in today's literature and cinema?

Imagine, however, traveling from Boston to Seattle in a horse and buggy. Or calculating the effects of climate change on the fauna and flora of Central Park with an abacus. Such antiquated technologies have little place in our lives today, yet countless aesthetic creations of the distant and far-distant past are seamlessly woven into the fabric of our contemporary realities. How, or why, is this so?

What if things aesthetic key deeply into our psychological make-up—which hasn't changed very much, if at all, through the ages? In other words, what if the primordial world of the Altamira cave painters, the place-making paradigms used by the Ancient Roman architects, and the emotional dramas of Homer's heroes still rattle around in our subconscious?

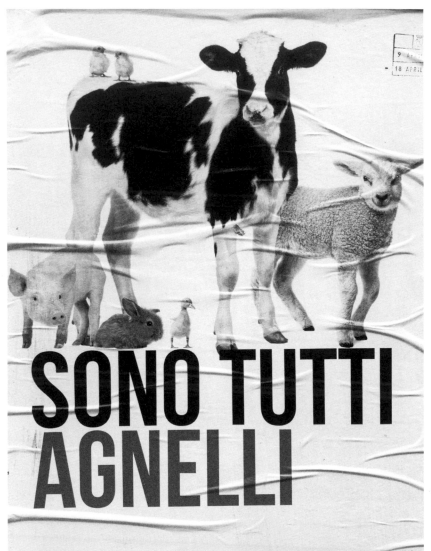

SONO TUTTI AGNELLI

Molti italiani non mangiano più l'agnello.
Ma gli animali sono tutti uguali.

Or, what if we are simply herd animals aesthetically expressing ourselves in a limited number of ways that happen to have remained fairly unchanged throughout our species' existence? New aesthetic ideals arise. And when they do they seem hugely momentous. Yet when these aesthetic leaps are viewed from a significant historical remove, the output of any group of creators working at any specific time and place seems uncannily similar.[9]

What if the truth is that everyone in the herd—including us creators of things aesthetic—simply wants to be like everyone else, just a little different (and perhaps a bit better)? And what if residing in these "little differences" and "bit betters" is really all that we humans truly need, value, or desire?

LAVS

TEXT NOTES

1. This can be clearly seen in the eight-hour documentary titled *The Beatles: Get Back* (2022), a film that chronicles the Beatles' activities in the months leading up to the band's last public performance.

2. Some creators intentionally repeat the same thing—or what looks or sounds like the same thing—over and over again. This is what Italian artist Franco Vimercati (1940–2001) did. His ostensible medium was black-and-white photography. His practice consisted of photographing the same quotidian objects— a fruit bowl, a vase, a bottle of mineral water, etc.—over and over again, and in precisely the same way. His procedure was exacting: With camera mounted on a tripod and the lighting just-so, he took one shot, then removed the camera from the tripod, disassembled the lighting, and packed everything away. At some unspecified later time he repeated the procedure, including the exact replication of the previous angle of view and lighting

scheme. . . . The differences between the resulting photographic prints? Minimally perceptible even to astute observers.

3. Deconstruction is, of course, omnipresent in the realms of fashion clothing and industrial design. But it is also widely practiced in the fine arts too. Instead of painting subject matter right-side up, some creators paint it upside down. Rather than discretely ending images at the canvas's edge, some creators continue it up, over, and around the picture frame. And in lieu of employing the most archival media possible, some creators paint or sculpt with fluids, ointments, creams and other materials that are virtually guaranteed to fade, disintegrate, or disappear.

4. Both art-book seller Dagny Corcoran and curator and writer Alison M. Gingeras steered this author to a better understanding of the relatively recent usage of the term "practice."

5. The sense that intuitions come not from the "me-self" may occur because information

from different parts of our brain somehow manages to evade our ventral medial prefrontal cortex, which, according to the latest scientific thought, is the cerebral region where the model of our selves in time and place—i.e., the me-self—is largely created.

6. Justin Bradshaw paints many other things too. www.justinbradshaw.it

7. The context analysis of the *I Ching* was performed by San Francisco–based social thinker Michael Phillips.

8. The Greek poet Homer, according to legend, lived sometime between the sixth and ninth centuries BCE. *The Iliad* and *The Odyssey* were stories initially passed on orally.

9. The author began actively noticing these samenesses after reading *Why Are Our Pictures Puzzles? On the Modern Origins of Pictorial Complexity* by art historian James Elkins.